HIDDEN FACES

NATIVE

NATIONS

VOLUME IV

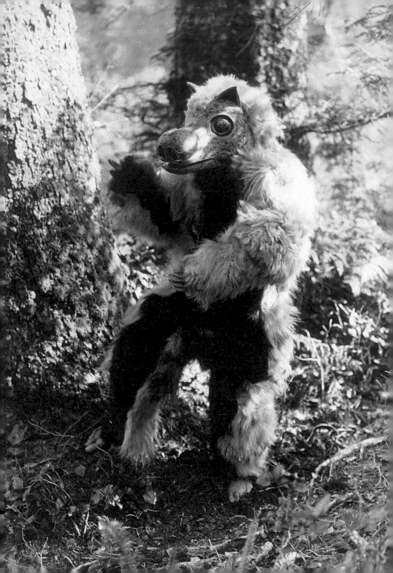

EDWARD S. CURTIS

HIDDEN FACES

Christopher Cardozo

PRODUCED BY CALLAWAY EDITIONS

A BULFINCH PRESS BOOK
LITTLE, BROWN AND COMPANY
Boston · New York · Toronto · London

First Edition

(COVER)
HASCHEBAÁD – NAVAHO, 1904

(FRONTISPIECE)
UNTITLED, 1914

ISBN 0-8212-2359-3

Library of Congress Catalog Card Number 96-76729

Bulfinch Press is an imprint and trademark of Little, Brown and Company (Inc.)
Published simultaneously in Canada by Little, Brown & Company (Canada) Limited

PRINTED IN HONG KONG

TABLE OF CONTENTS

PREFACE

"No people have a more elaborate religious system than our aborigines, and none are more devout in the performance of the duties connected therewith. There is scarcely an act in the Indian's life that does not involve some ceremonial performance or is not in itself a religious act, sometimes so complicated that much time and study are required to grasp even a part of its real meaning. . . ."

— Edward Sheriff Curtis, "General Introduction," The North American Indian, *Volume I*, 1907.

During the summer of 1900, ethnographer/photographer Edward S. Curtis accompanied noted Indian scholar George Bird Grinnell into the field to visit the Piegan tribes of northwestern Montana. In my opinion, this two-week trip was the key, watershed experience of Curtis's career, as it catalyzed the thirty-year photographic and textual study of Native American life and ritual that was to absorb most of Curtis's adult life. Grinnell knew the Blackfeet and Piegan peoples intimately and was able to provide Curtis with his first unfettered exposure to Native American religious practices, myths, and rituals. This newfound access and information initiated Curtis's enduring commitment to capturing heretofore hidden aspects of native spiritual life and practices. Against great odds, he maintained this commitment for three decades, recording every aspect he could of a valuable and vanishing culture and way of life.

While Curtis photographed numerous ceremonies and kept detailed written records of their meanings, the traditional songs

employed, and evolved choreography, his photographs of masked and costumed individuals clearly stand apart from anything else he did. The intensity and visual sophistication of many of these images is unmatched in all but a very few photographs of Native Americans. The photographs of masks and costumes often evoke the mystery, sophistication, and artistry of a particular culture and its myths, celebrations, and rites, in a way unequaled by any other photographer.

Interestingly, few tribes appeared to make extensive use of masks, relying instead on clothing, paint, or other bodily adornments to create the prescribed atmosphere or characterization. In fact, nearly ninety percent of the mask and costume photographs that Curtis published were from only two tribes, the Navaho peoples of Arizona and the Kwakiutl of British Columbia. The array and number of the mythical ceremonial characters from these two tribes was so large that Curtis did not seem to tire of capturing them on film. He filled sizable portions of the two volumes of The North American Indian devoted to the Navaho and Kwakiutl with these images, as well as producing many unpublished depictions of these assorted creatures and mythical beings.

This volume presents reproductions of a select number of what I deem to be Curtis's most interesting, artistic images from The North American Indian, and also incorporates a number of photographs that have never been published before, not even by Edward S. Curtis. These images are reproduced from rare Curtis prints in my personal collection, which contains many unique and often unknown examples of the photographer's work that I have amassed over the past twenty years. — C.C.

The . . . beings on whom initiates into the fraternity of the winter ceremony depend for their supposed magic power are for the greater part preternatural animals or fabulous creatures of animal form, and as a rule the dancer mimics his tutelary being. Among the most important of these creatures of the fancy are sísiutl, *a great serpent with a head at each end. . . .*

In this costume the dancer appears at the door of the house where the winter dance is in progress. He goes into the secret room at the rear, dons the sísiutl *mask . . . and reappears to perform his dance. . . .*

The sísiutlilahl *makes his entrance with a club in his hand after striking the door with the weapon. He walks round the fire and goes behind the singers, crying* aí he i. . . ! *The singers begin to use their batons, and behind them a man's head with horns slowly rises far enough to show itself to the people. The two hinged arms representing the body and heads of the double-headed snake* sísiutl *are at first folded together, extending straight back behind the man's head, but they are now unfolded and spread out on both sides. The apparatus is manipulated by a man concealed behind the singers.* Volume X, pages 161, 212, 213.

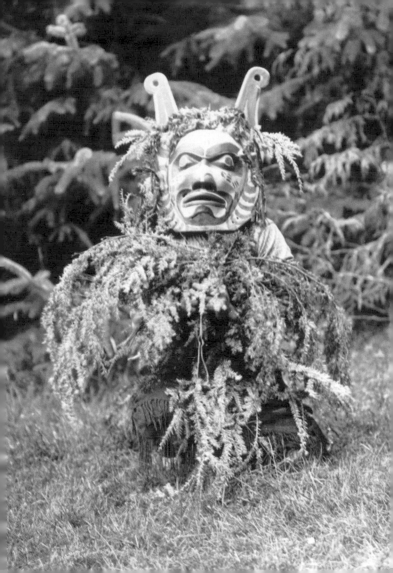

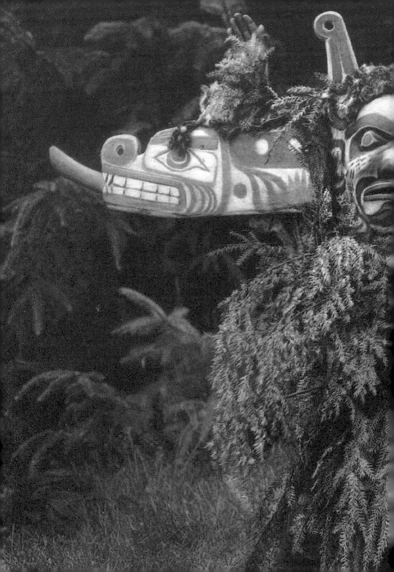

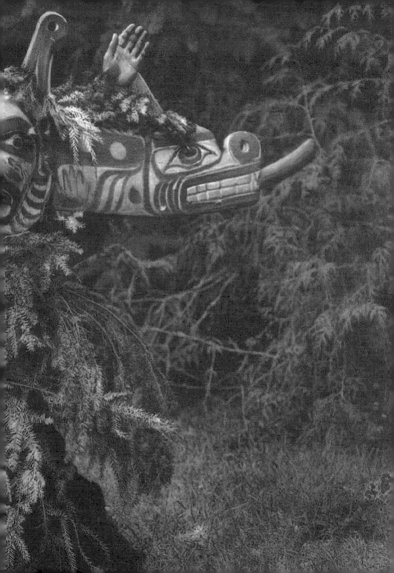

NÚHLIMAHLA – QÁGYUHL, 1914

The núhlimahla pretends to be crazy, and assists the grizzly-bears in protecting the hamatsas. . . .

Most numerous of all the dancers are nunúhlumahla, who personate fools and are characterized by their devotion to filth and disorder. They do not dance, but go about shouting wi...., wi...., wi...! They are armed with clubs and stones, which they use upon anything that arouses their repugnance for beauty and order. Excreta are sometimes deposited in the houses, and the "fools" fling nasal mucus on one another. This use of mucus is in fact the salient characteristic of núhlimahla, in conformity with the myth of the original núhlimahla, who . . . returning from an encounter with some supernatural beings, would constantly smear the excretion of his nose over his body. In the initiation of núhlimahla the older members fling mucus upon him. It is the duty of these dancers to compel the observance of the regulations governing the deportment of people in the presence of hamatsas, and to inflict corporal punishment on offenders. Volume X, pages 157, 215-216.

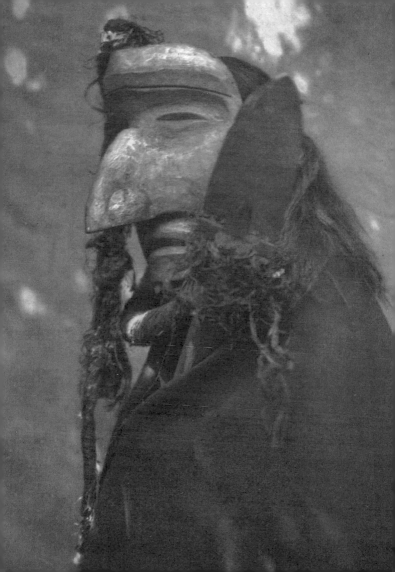

HASCHEBAAD – NAVAHO, 1904

In Navaho mythology there are numerous references to benevolent female deities, who are personified in medicine rites by men wearing masks. . . . Haschebaád may be translated "female deity," or "goddess." Volume I, page 111.

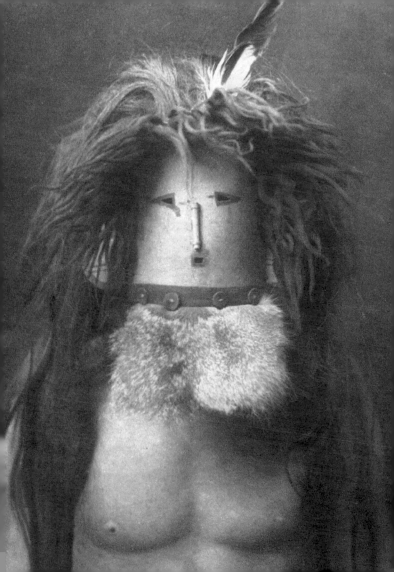

MASKETTE – NUNIVAK, 1928

Of maskettes there are very many. Those seen on Nunivak are for wear on the forehead. The common forms are the heads of animals, birds, or fish mounted on hoops or head-bands of a size to fit the head. One such, a fowl maskette (túngumihslúkuh), was the head of a predatory bird bearing a fish in its mouth. . . . A miniature spear, feather-mounted, was stuck in the top of the bird's head. Three tail-feathers, two diametrically opposed on each side and one in the rear, were inserted on the hoop. Volume XX, page 39.

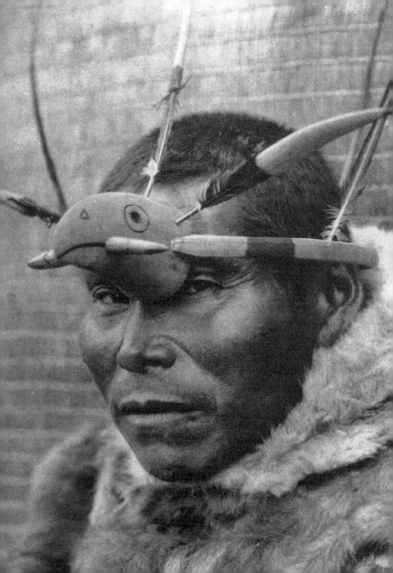

NÁNE – QÁGYUHL, 1914

"Grizzly-bear." . . . The initiate imitates the bear in dress and action.
Volume X, page 157.

NÁNE SONG

When the great Grizzly-bear cries u! hu! nan! hin!
The people will fall in fright as if thrown from a tilted plane.
Volume X, page 320.

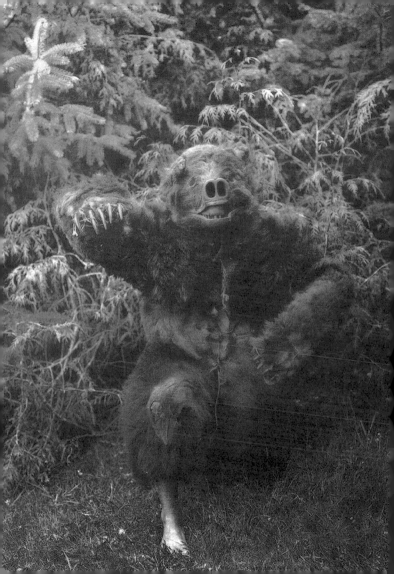

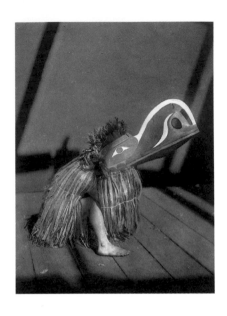

KALÓQUTSUIS – QÁGYUHL, 1914

In the house of Páhpaqalanóhsiwi live his servants: Kwáhqaqalanóhsiwi ("raven of Páhpaqalanóhsiwi"), who sits at the door and performs the duty of "food taster" for his master by pecking out the eyes of his prey: Kyénkalatlulu, a woman who procures human bodies for him and who, when there is no food, offers him her arm to bite; Hóhhuq, the monster bird who crushes their skulls: Nánstâlihl-Páhpaqalanóhsiwi ("grizzly-bear of the Páhpaqalanóhsiwi"), who tears up the bodies and gives the flesh to his master; and Kalóqutsuis ("curved beak of the upper world"), a huge bird. Volume X, page 160.

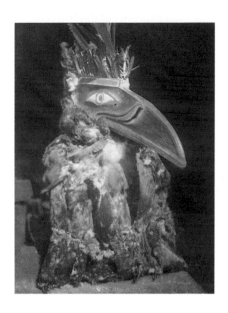

KWÁHWUMHL – KOSKIMO, 1914

This "raven mask" is provided with a coat of cormorant-skins, which completely covers the figure of the dancer. It is used in the núnhlim ceremony. Volume X, page 234.

TÓNENILI – NAVAHO, 1904

Tónenili, Water Sprinkler, is the Rain God of the Navaho. He it is who sends the rain, the hail, and the snow, and causes thunder and lightning. The personator of this god in the ceremonies assumes the additional character of a clown and as such creates much merriment in the dances in which he appears. His apparel consists principally of spruce boughs and a mask. Volume I, page 107.

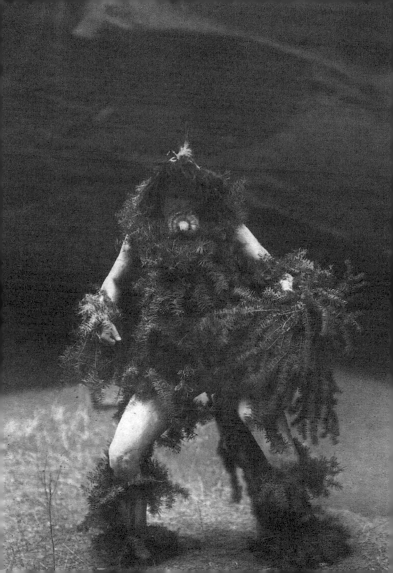

WAITING IN THE FOREST – CHEYENNE, 1910

At dusk in the neighborhood of the large encampments young men, closely wrapped in non-committal blankets or white cotton sheets, may be seen gliding about the tipis or standing motionless in the shadow of the trees, each one alert for the opportunity to steal a meeting with his sweetheart. Folio plate 218, Volume VI.

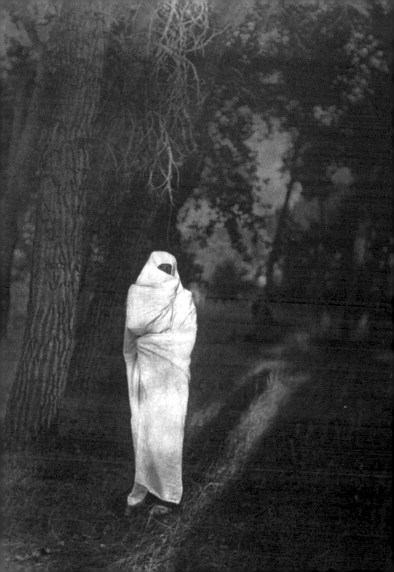

HAMÍ – KOSKIMO, 1914

The mask of hamí ("dangerous thing") is used in the núnhlim ceremony. Volume X, page 236.

APACHE GÁUN, 1908

The Gáun Bagúdzitash, or Dance of the Gods, is . . . unquestionably the most popular ceremony conducted by the Apache.

Four always, but generally five, deities are impersonated in this dance — Gaunchiné of the east, Gáuncho of the south, Gáun of the west, Gaunchí of the north, and Gauneskíde the fun-maker. These are arrayed in short kilts, moccasins, and high stick hats supported upon tightly fitting deerskin masks that cover the entire head. . . .

For the dance a circular plot of ground . . . is cleared of stones and brush, and four small cedar trees are planted about its edge, one at each of the cardinal points. All in attendance assemble in a circle outside the trees, leaving an opening at the eastern side. Unheralded the five masked personators march in from the east and take position in front of the cedar trees, the fifth man standing behind the fourth at the northern side. Four drummers with small drums and an indefinite number of drummers around a large one, at a signal from the medicine-man in charge, who sings, begin drumming. The personated gods dance all about the circle, making motions with their sticks as if picking up and throwing something away, followed by blowing with the breath for the purpose of expelling evil spirits from their midst. While this is going on the fifth masker, Gauneskíde, performs antics designed to amuse the audience. Volume I, pages 47-48.

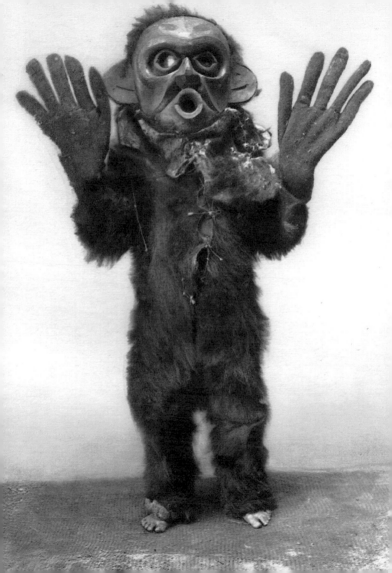

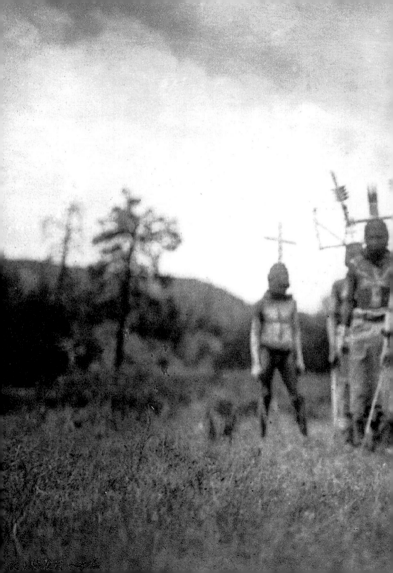

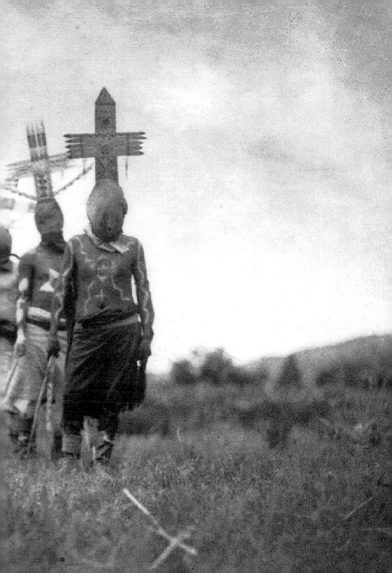

SUBSTITUTE SACRED
HEAD-DRESS – PIEGAN, 1910

When a female ikôw *desires to hold in her lodge an informal religious
dance, or to attend such a function elsewhere, she prepares a head-dress
similar to, but not exactly like, that which she wore as pledger in the
Sun Dance.* Volume VI, page 49.

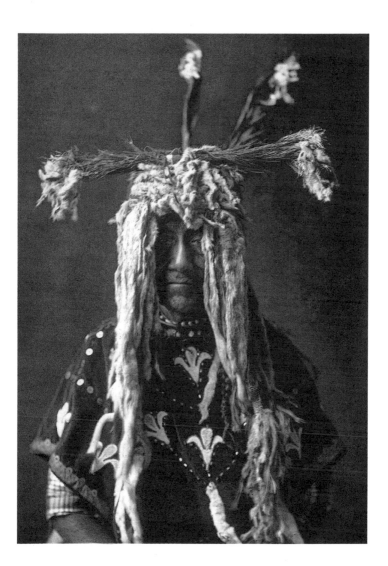

WAÍHUSIWA, A ZUÑI
KYÁQIMÂSSI, 1903

Kyáqimâssi ("house chief") is the title of the Shíwanni of the north,
the most important of Zuñi priests. Waíhusiwa in his youth spent the
summer and fall of 1886 in the East with Frank Hamilton Cushing,
and was the narrator of much of the lore published in Cushing's Zuñi
Folk Tales. *A highly spiritual man, he is one of the most steadfast*
of the Zuñi priests in upholding the traditions of the native religion.
Folio plate 612, Volume XVII.

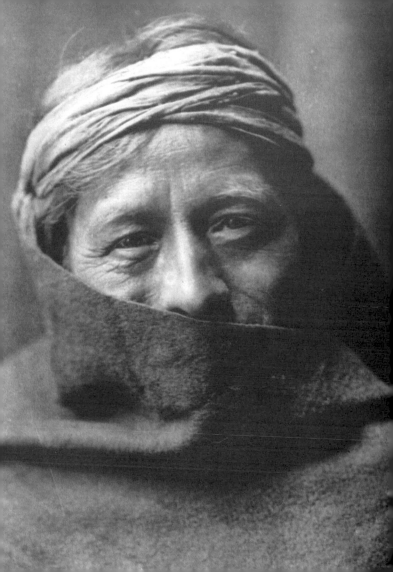

HASCHÓGAN – NAVAHO, 1904

Second in general importance only to Haschélti among Navaho deities is the House God, here shown. His position among the gods is quite parallel with that of peace chief among Indians in life. Like the majority of the myth characters he has numerous counterparts in the various world quarters. Volume I, page 95.

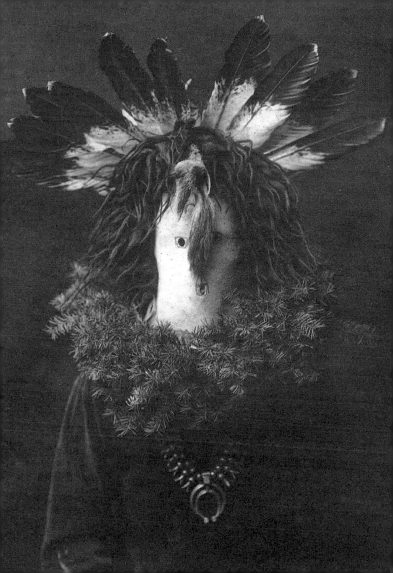

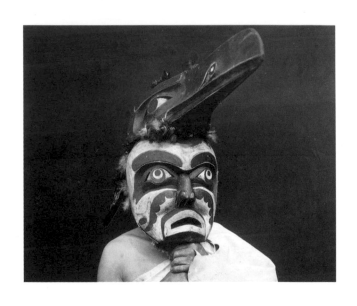

RAVEN MA – QÁGYUHL, 1914

Kwákwahulahl ("raven embodiment"). . . . The initiate wears a costume and mask representing the raven. Volume X, page 157.

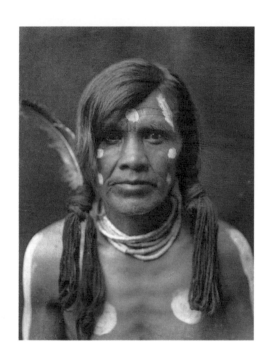

MÓ^NWA^N ("SHINING LIGHT") –
NAMBÉ, 1905

Nambé is situated in the lower foothills of Truchas peaks, a spur of the rugged
Sangre de Cristo range, sixteen miles north of Santa Fe and on Nambé creek,
an easterly tributary of the Rio Grande. Volume XVII, page 61.

GÁᴺASKIDI – NAVAHO, 1904

This is the personation of the Navaho God of Harvest. The name signifies "Hunchback." He is represented always in a stooping posture, carrying a staff to aid him in supporting a burden of corn, bean, pumpkin, and other seeds which he carries upon his back. Volume I, page 105.

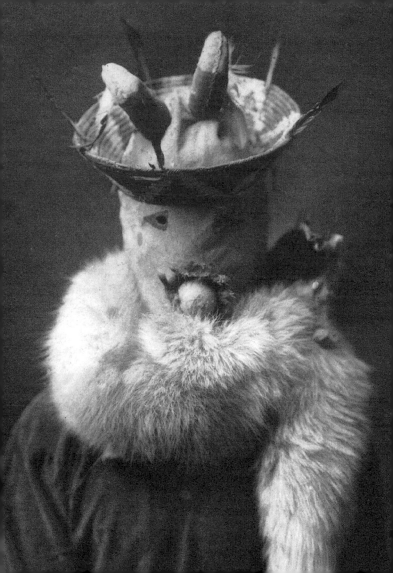

HÁMASILAHL – QÁGYUHL, 1914

"Wasp embodiment." Volume X, page 156.

MASKED DANCERS –
QÁGYUHL, 1914

The winter ceremony is called tsétsehka *("secrets," or "tricks of legerdemain"), a name which aptly characterizes the great majority of the component performances.* Volume X, page 170.

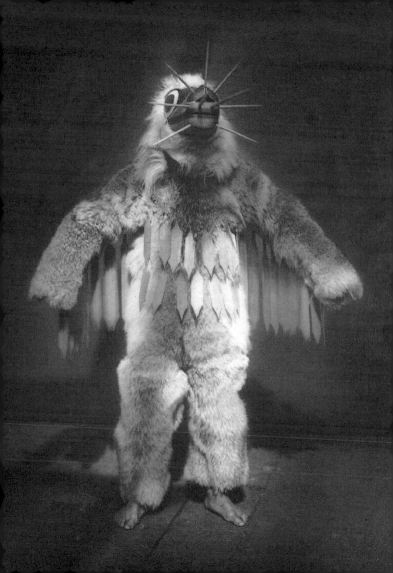

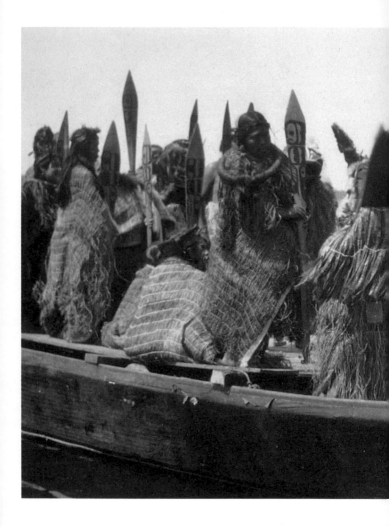

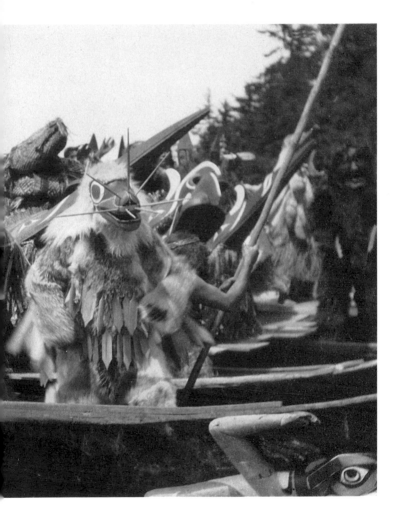

NÚHLIMKILAKA – KOSKIMO, 1914

Núhlimkila (or Núhlimkilaka, the feminine form) is a forest spirit that causes one to become confused and to lose one's way. The name means "bringer of confusion." The mask is used in the núnhlim ceremony. Volume X, page 240.

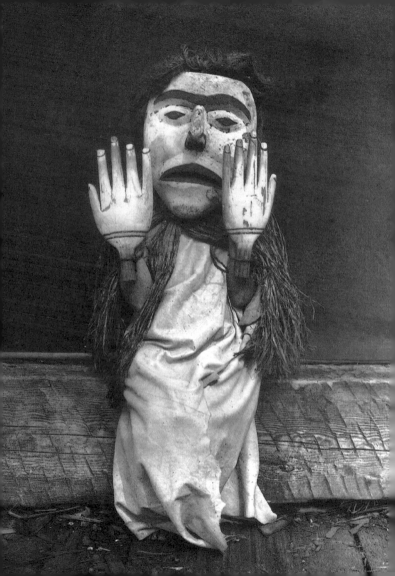

A TLU'WULAHU MASK –
TSAWATENOK, 1914

*The mask shows the Loon surmounting the face of the anthropomorphic
being into which the bird transforms itself at will.* Volume X, page 242.

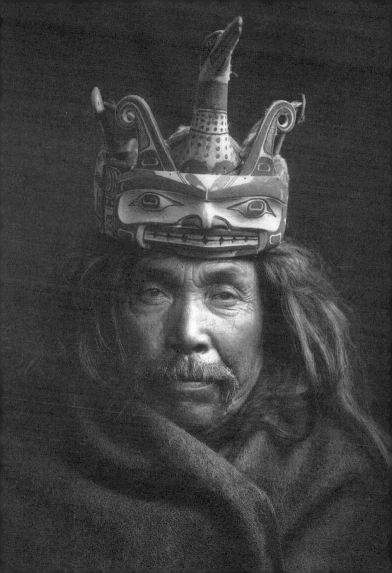

KÓMINÂKA DANCER –
KWAKIUTL, 1914

When she emerged from the woods in the morning she wore only a scanty girdle of hemlock twigs with a wreath and arm- and leg-rings of the same material. . . . After dancing for a while on her yútsu, she moves slowly round the room, counter-clockwise, and when for the second time she reaches the rear, she dances back and forth between the fire and the place of honor. Her dancing consists of slow steps taken with a little spring at the knees, while the palms are held upward, the arms being half extended, first at one side then at the other. This is suggestive of the carrying of a dead body for the hamatsa. Volume X, page 178.

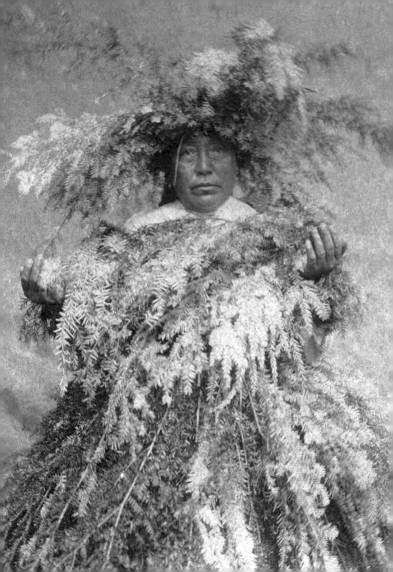

(OPPOSITE)

HASCHÉZHINI – NAVAHO, 1904

Black God, the God of Fire. An important deity of the Navaho, but appearing infrequently in their mythology and ceremonies. Volume I, page 103.

(OVERLEAF)

CEREMONIAL MASK – NUNIVAK, 1928

While the wearing of wooden masks (agaíyut) in various festivals and ceremonies forms a part of ritualistic procedure, it is especially difficult to procure any knowledge of their significance chiefly because the customs of the people have become so modified that complete and reliable information as to masks is well-nigh unobtainable. . . .

Surrounding the face is a thin wooden hoop held in place by three wooden pegs, two jutting out angularly from the forehead and one from the chin. On the top of this hoop, three tail-feathers, about three inches apart, are inset. Two small hands carved from wood and mounted on feathers are next inset, diametrically opposed. Below there are two more feathers, similarly opposite; and last come two feet mounted in the same manner. . . . Volume XX, page 38.

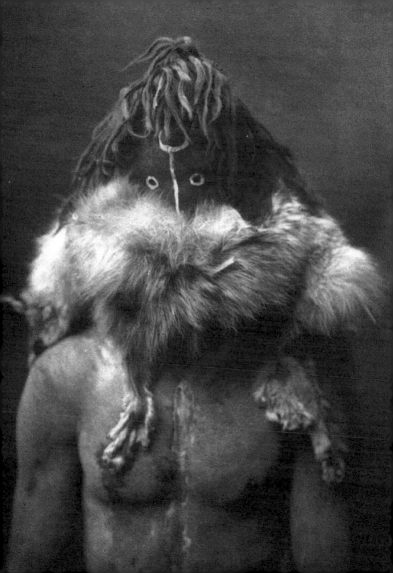

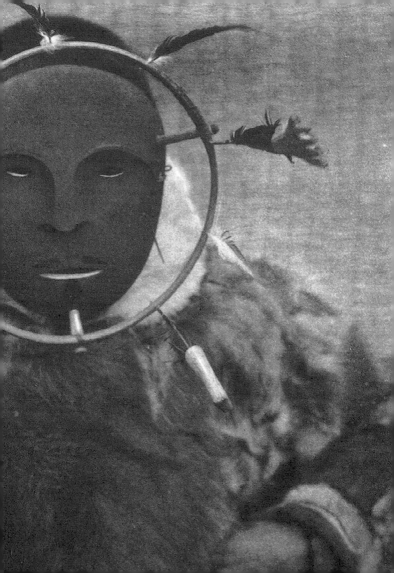

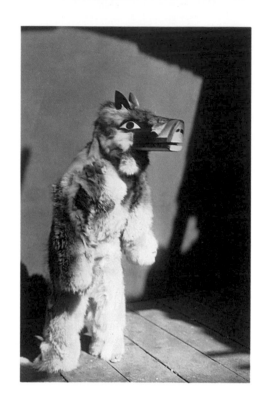

WÁSWASLIKYI – QÁGYUHL, 1914

"Dog again and again," therefore, chief dog . . . or a'wásilahl
("dog embodiment"). . . . *The initiate wears the dog costume and
mask.* Volume X, page 157.

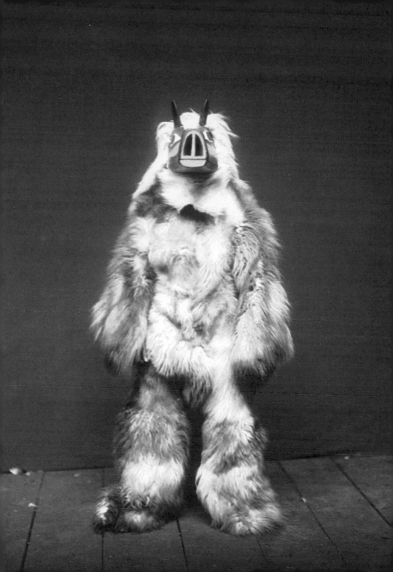

WOMAN SHAMAN LOOKING
FOR CLAIRVOYANT VISIONS –
CLAYOQUOT, 1915

The Nootka tribes, composing one branch of the great Wakashan linguistic stock, of which the Kwakiutl are the other, inhabit the west coast of Vancouver island from Cape Cook to Port San Juan, and, in the United States, the territory about Cape Flattery from Hoko creek to Flattery rocks. . . . The Nootka of Vancouver island embrace a considerable number of tribes inhabiting favorable portions of the shores of the intricate fiords that cut deep into the island. Among the better known of these tribes are the Nitinat, Clayoquot, and Kyuquot. . . .

The power to heal or to cause sickness is generally inherited. That son (or daughter) of a medicine-man (or medicine-woman) selected as his successor is sent at an early age into the woods to bathe and rub the body with hemlock or a certain kind of grass. The baths are taken frequently, sometimes four times a day and four times at night, and the youth may remain away from home for several days, wandering from place to place, bathing in every stream and lake and eating just enough roots and berries to sustain life. Prayers are addressed to the Sun, the Moon, and other deities. It is not expected that a spirit will be seen before the end of the first year. These habits, in a milder form, are continued even after the power has been obtained. Volume XI, pages 3, 45-46.

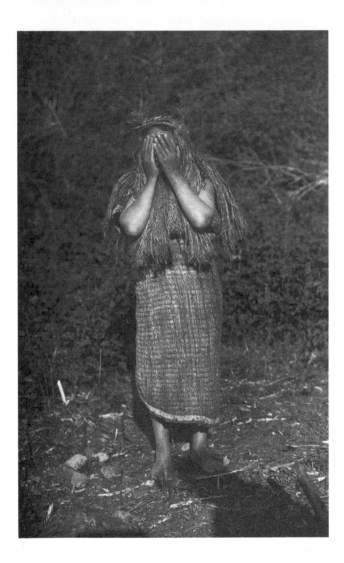

(OPPOSITE)

TOBADZISCHÍNI – NAVAHO, 1904

This is Born From Water, the second of the twin miracle-performing sons of Yólkai Estsán, the White-Shell Woman. His brother is Nayénezgani. Volume I, page 103.

(OVERLEAF)

QÚNHULAHL – QÁGYUHL, 1914

The initiate is caught arrayed in a suit and a mask representing the fabulous thunderbird. Volume X, page 157.

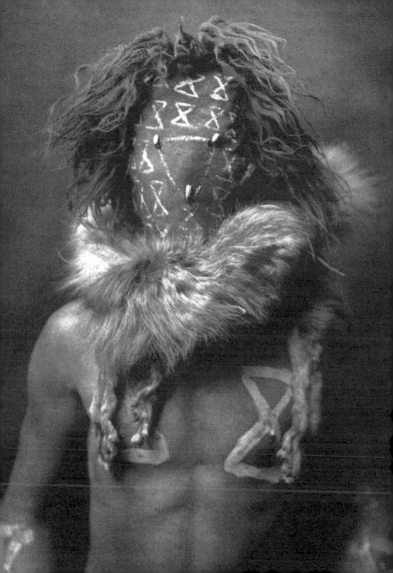

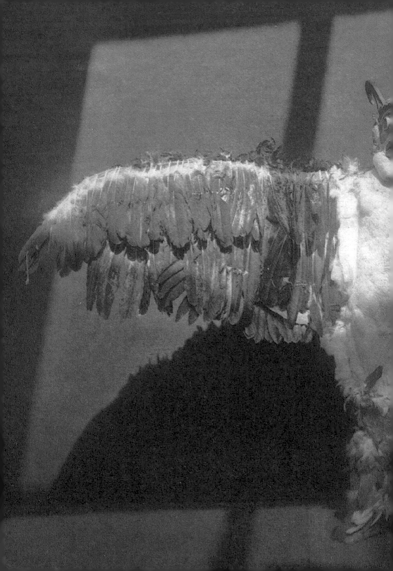

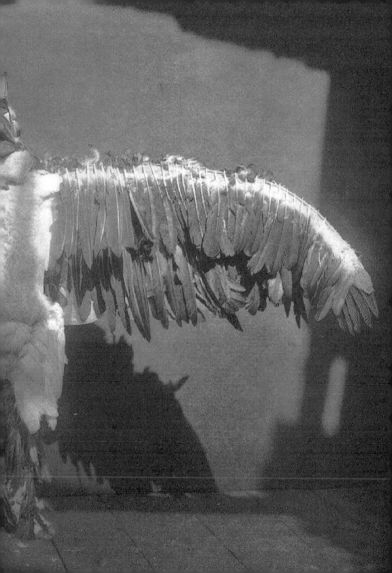

TÁWIHYILAHL – QÁGYUHL, 1914

"Mountain-climber [i.e., mountain-goat] embodiment." Volume X, page 156.

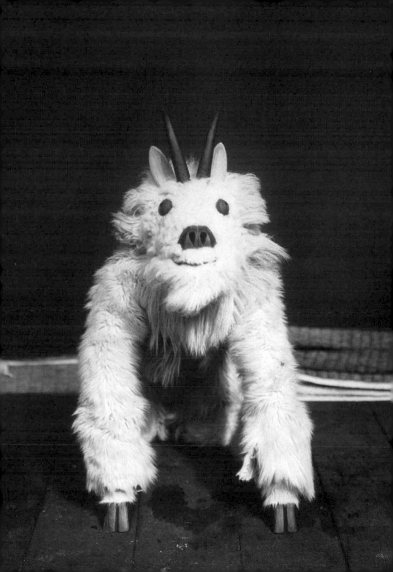

HASCHÉLTI, HASCHÉBAÁD, ZAHADOLZHÁ – NAVAHO, 1906

The Navaho life is particularly rich in ceremony and ritual, second only to some of the Pueblo groups. Note is made of nine of their great nine-day ceremonies for the treatment of ills, mental and physical. There are also many less important ceremonies occupying four days, two days, and one day in their performance. . . . Almost every act of their life — the building of the hogán, the planting of crops, etc. — is ceremonial in nature,¹ each being attended with songs and prayers. Volume I, page 138.

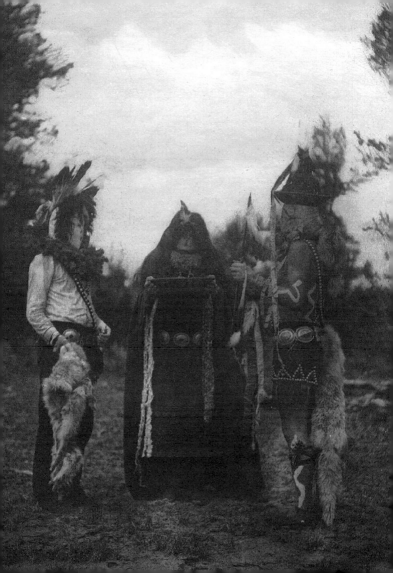

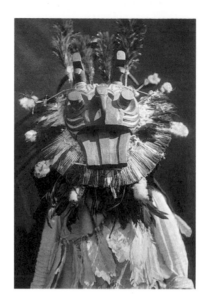

MASKED DANCER – COWICHAN, 1914

A COWICHAN MASK, 1912

The masked dancers of the Vancouver Island Cowichan . . . represent the original mythical ancestors of the people, and appear only at potlatch festivals, never in the winter dances. The masks are obtained by inheritance, but the name of the ancestor is not necessarily conferred upon the man who receives the mask representing that ancestor. Volume IX, page 115.

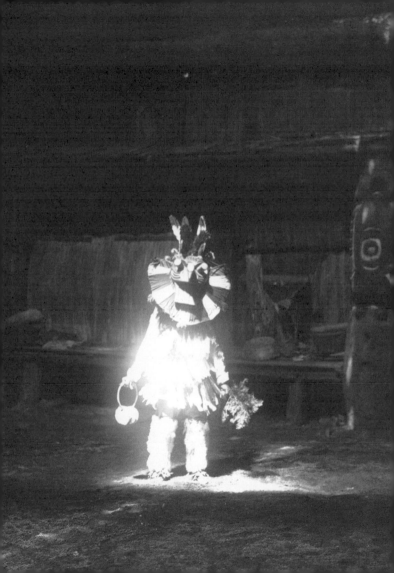

DEVILFISH MASK AND
MASK OF THE OCTOPUS HUNTER –
QÁGYUHL, 1914

The Octopus Hunter . . . performs in the tlu'wuláhu ceremony, dramatically presenting a Bellabella myth. . . . Following a person wearing a mask that represents an octopus, the hunter enters the house and goes about peering at the floor, poking his stick here and there as if searching on the beach for an octopus. At last he catches sight of the octopus masker, and thrusts his sharp stick into the "body" of the mask. The legs begin to curl up, indicating that the monster is killed. Volume X, page 298.

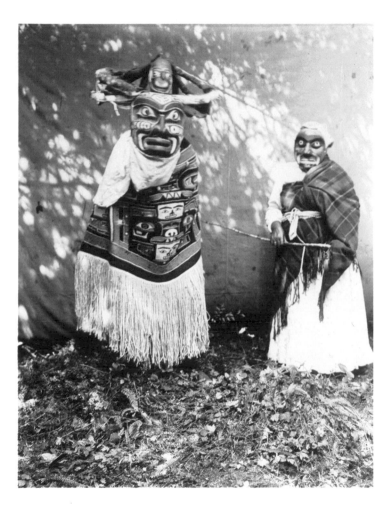

PÁQUSILAHL EMERGING FROM THE WOODS – QÁGYUHL, 1914

This character represents páqus, a wild man of the woods. Volume X, page 156.

PÁQUSILAHL SONG

Oh, you wonder, magic power! You great wonder, magic power!
Everywhere the great one will select for destruction.
His weapon how wonderful!
This great Páqusilahl, this our great, best one in the world.
Volume X, page 319

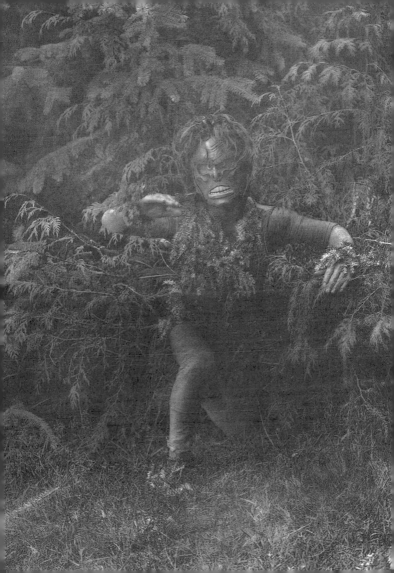

(OPPOSITE)

SUN DANCE PLEDGERS –
CHEYENNE, 1911

During the forenoon a final preparation of the pledgers to depart from the preliminary ceremonial lodge was made, and early in the afternoon they took up their journey toward the half-constructed sun-lodge. As the principal actors in the drama emerged from the lodge, the pledger's wife was in the lead. . . . Behind the woman came the chief priest, and next the two pledgers. They were painted on both body and face with perpendicular lines of white. Volume VI, page 128.

(OVERLEAF)

KÓTSUIS AND HÓHHUQ –
NAKOAKTOK, 1914

These two masked performers in the winter dance represent huge, mythical birds. Kótsuis (the Nakoaktok equivalent of the Qágyuhl Kalóqutsuis) and Hóhhuq are servitors in the house of the man-eating monster Páhpaqalanóhsiwi. . . . The mandibles of these tremendous wooden masks are controlled by strings. Folio plate 336, Volume X.

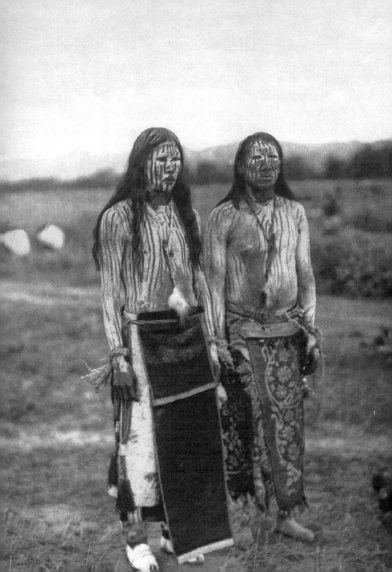

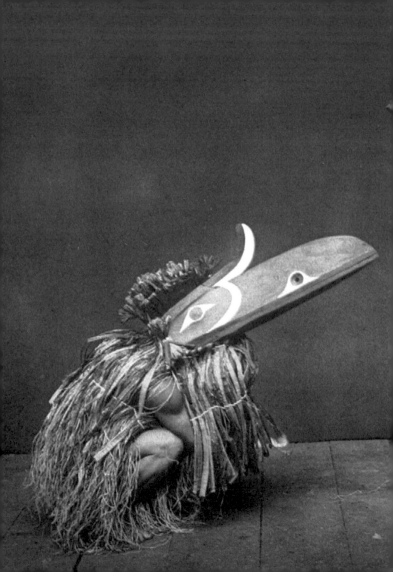

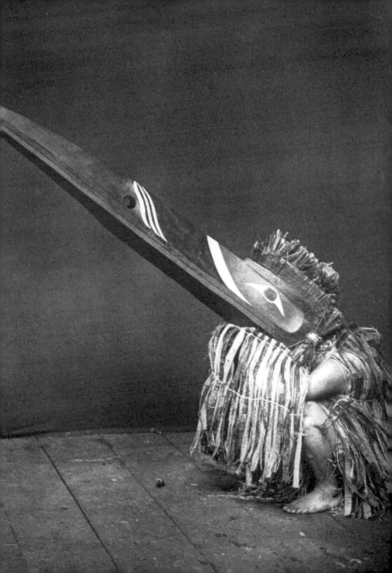

KWAKIUTL, 1914

The Kwakiutl have no conception of a personified, supreme power. They believe in many spirits — some inhabiting animal bodies, others purely imaginary — which can and do impart supernatural power to men who obtain their pity by austere bodily purification. The principal ceremony is a series of quasi-religious performances during about four months of the winter. The ceremony is controlled by a fraternity of men, women, and children, and the active dancers are divided among a large number of degrees. The various performances consist of the dramatization of myths, the personification of mythic creatures, and the practice of legerdemain. The most important dancer is the hamatsa, who is supposed to swallow human flesh in personating the man-eating spirit Páhpaqalanóhsiwi. Volume X, page 304.

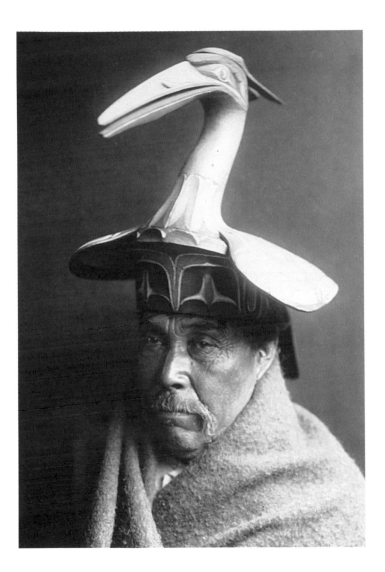

HASCHÉLTI – NAVAHO, 1904

This, the Talking God, is the chief character in Navaho mythology. In the rites in which personated deities minister to a suffering patient this character invariably leads, carrying a four-piece folding wand, balíl, and uttering a peculiar cry. Volume I, page 93.

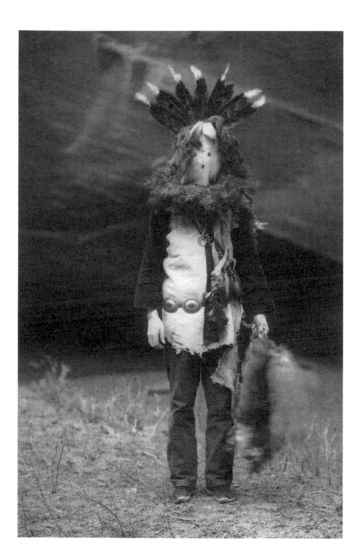

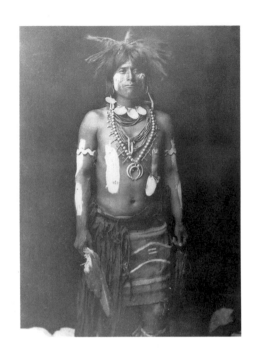

SNAKE DANCER IN COSTUME –
HOPI, 1900

Now the members begin to prepare for the dance. Pink clay is smeared over moccasins, kilts, and other parts of the paraphernalia to be worn, and cornsmut mixed with some of the "man medicine" made on Komók-totókya day is rubbed over the body. Then pink clay mixed with "man medicine" is smeared on the forearms, the calves, and the upper right side of the head. The chin is whitened, the rest of the face blackened. Volume XII, page 152.

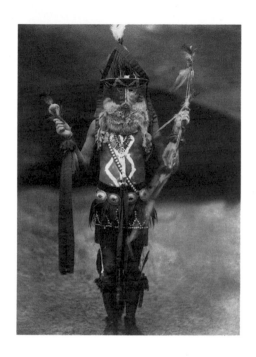

ZAHADOLZHÁ – NAVAHO, 1904

These deific characters in Navaho mythology, though beneficent always,
have no special functions to perform. The name means "Fringe Mouth"
and has no ascertainable significance other than that these spirits, whose
abode is in the water, are supposed to have peculiar markings about their
mouths. Rescue from drowning invariably redounds to the glory of these
gods. Volume I, page 109.

NAYÉNEZGANI – NAVAHO, 1904

Two of the most important characters in Navaho mythology are twin miracle-performing sons of White-Shell Woman, Yólkai Están, chief goddess. This plate pictures the leader of the two — the first conceived and the first-born, whose father is the sun. His name means "Slayer of Alien Gods," from ana, alien; ye, gods; agáni, to kill. By him, with the assistance of Tobadzischíni, his twin brother, were killed numerous bird, animal, rock, and human monsters, typifying evils, who wantonly destroyed human life. Volume I, page 99.

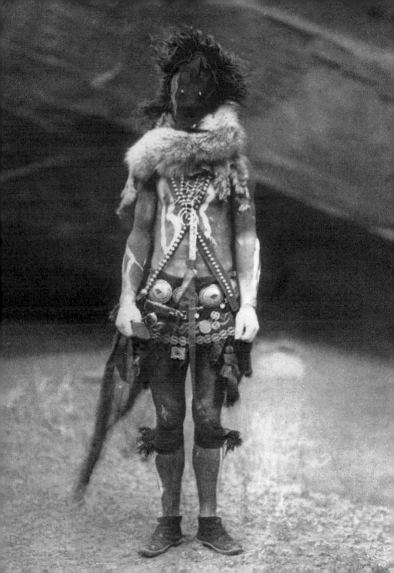

MÓSA – MOHAVE, 1903

Both men and women have their faces tattooed, generally in streaks across the forehead or down the chin. Face painting is also practised to a limited extent. Volume II, pages 50-51.

It would be difficult to conceive of a more thorough aboriginal than this Mohave girl. Her eyes are those of the fawn of the forest, questioning the strange things of civilization upon which it gazes for the first time. She is such a type as Father Garcés may have viewed on his journey through the Mohave country in 1776. Folio plate 61, Volume III.

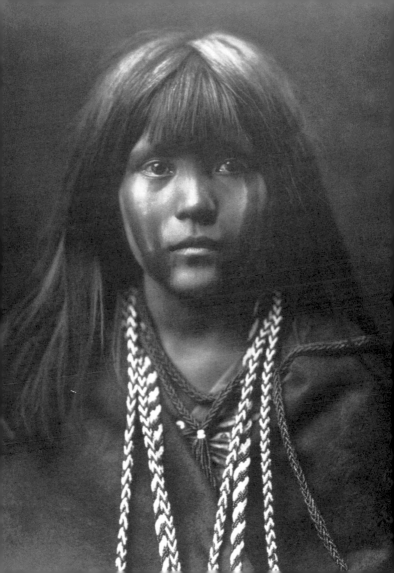

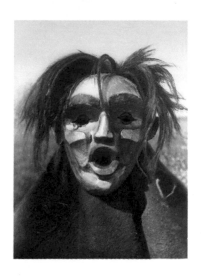

(ABOVE & OPPOSITE)

TSÚNUKWALAHL – QÁGYUHL, 1914

The initiate wears the costume and mask of the mythical being tsúnukwa. . . .

A woodland monster of human form, with huge, pendent breasts and protruding, rounded mouth. . . .

A man who has been initiated as a fsúnukwa *dancer . . . always appears to be sleepy and dazed, like a fsúnukwa, and when any one points a finger at him and moves it slowly in a circle before him, he lies down and falls asleep, no matter where he may be.* Volume X, *pages* 157, 161, 184.

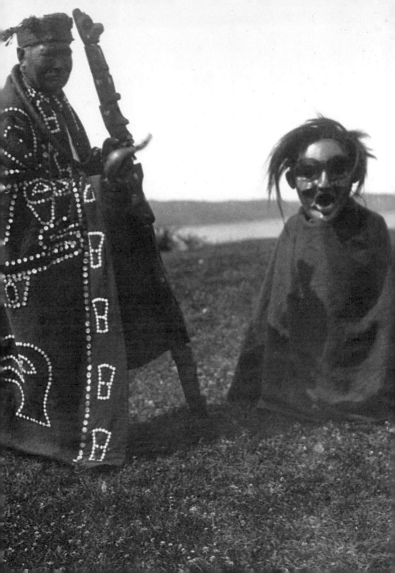

(OPPOSITE)

A TLU'WULÁHU COSTUME – QÁGYUHL, 1914

The dancer is a woman wearing a Chilket blanket, a hamatsa neck-ring, and a mask representing a deceased relative who was hamatsa. Volume X, page 244.

Háma'ts (há'map, *to eat*). . . . *The hamatsas are supposed to eat human flesh as a ceremonial rite.* Volume X, page 156.

(OVERLEAF)

MASKED DANCERS – QÁGYUHL, 1914

The plate shows a group of masked and costumed performers in the winter ceremony. The chief who is holding the dance stands at the left, grasping a speaker's staff and wearing cedar-bark neck-ring and head-band, and a few of the spectators are visible at the right. At the extreme left is seen a part of the painted máwihl through which the dancers emerge from the secret room; and in the centre, between the carved house-posts, is the Awaitala háms'pek, showing three of the five mouths through which the hamatsa wriggles from the top to the bottom of the column. Folio plate 358, Volume X.

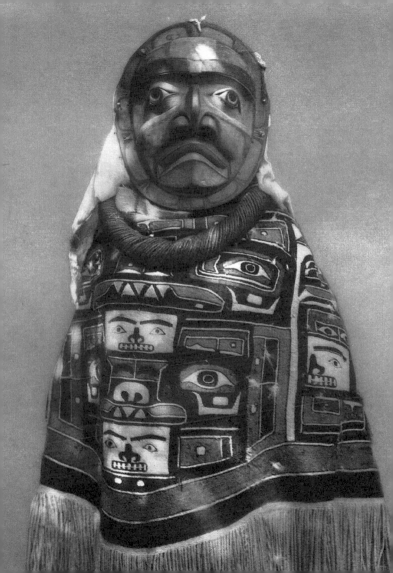

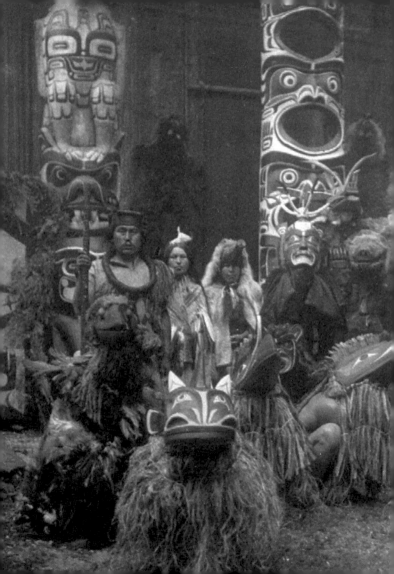

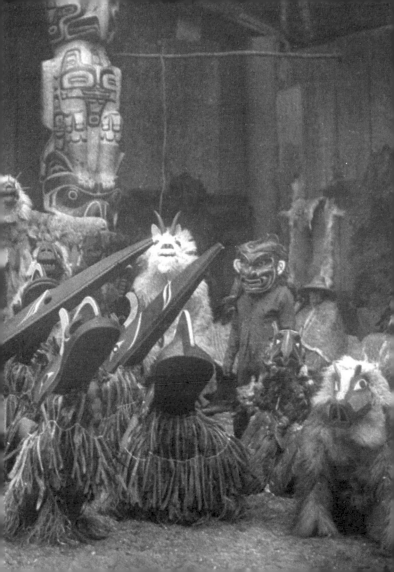

THE GRIZZLY-BEAR –
KWAKIUTL, 1914

It is the duty of bear dancers to guard the dance house and to punish those who fail to observe rules governing the privileges of the hamatsas. In former times, it is said, such a lapse was not seldom punished with death. Volume X, page 157.

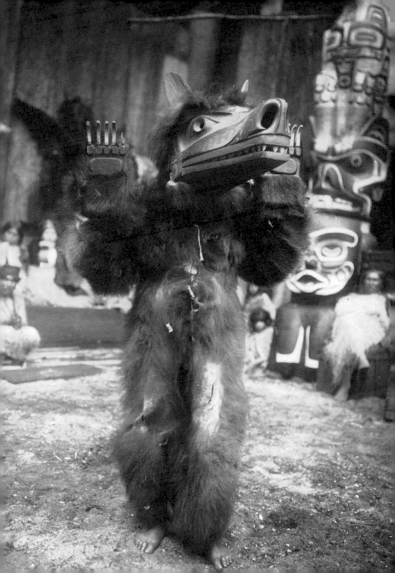

LIST OF PLATES

ACKNOWLEDGMENTS

I would like to acknowledge my profound personal and professional debt to Edward S. Curtis. Without his extraordinary vision, talents, and commitment, none of this would be possible. Having had the opportunity to be so intimately involved with his work has been one of the great joys of my adult life.

I would also like to express my sincere gratitude to the many wonderful individuals at Callaway Editions, Inc. Their commitment to bringing the work of Edward Curtis to the world involves much hard work. I particularly want to thank my patient and capable editor Robert Janjigian, as well as Nicholas Callaway, Richard Benson, True Sims, Jessica Allan, Jennifer Wagner, Daniel Benson, and the many others at Callaway Editions who played such important roles in making this book a reality.

I also wish to thank my assistant Angela Spann for her hard work and many contributions, and Darren Quintenz and Howard Gottlieb, whose faith in me and whose deep interest in the work of Edward Curtis have also been instrumental in making all of this possible. — C.C.

COLOPHON

Hidden Faces *was produced by Callaway Editions, Inc.
70 Bedford Street, New York, NY 10014.
Robert Janjigian, editor. Jennifer Wagner, designer.*

Type was composed with Quark Xpress software for Macintosh using a redrawn Franklin Gothic Extra Condensed typeface and the Centaur typeface from Adobe Systems.

The images selected for this volume were reproduced from an archive of Edward S. Curtis photographs contained on a CD-ROM. Richard and Daniel Benson converted these RGB files to a single gray-scale file, from which four printing negatives were generated. These negatives were printed as quadratones with ink colors that replicate the hues found in Curtis's original photogravures.

Captions accompanying the Curtis images presented herein are excerpts from Curtis's original texts found in the twenty volumes and twenty portfolios of The North American Indian, *published from 1907 to 1930, available on CD-ROM through Christopher Cardozo, Inc., 2419 Lake Place, Minneapolis, MN 55405.*

The endpaper design was created using symbols originally printed on the title pages of volumes I, II, III, IV, V, VII, VIII, X, XII, XIII, XIV, XV, XVIII and XIX of The North American Indian.

This book was printed and bound by Palace Press International, Hong Kong, under the supervision of Raoul Goff.